STAMPABILITY

HEARTS

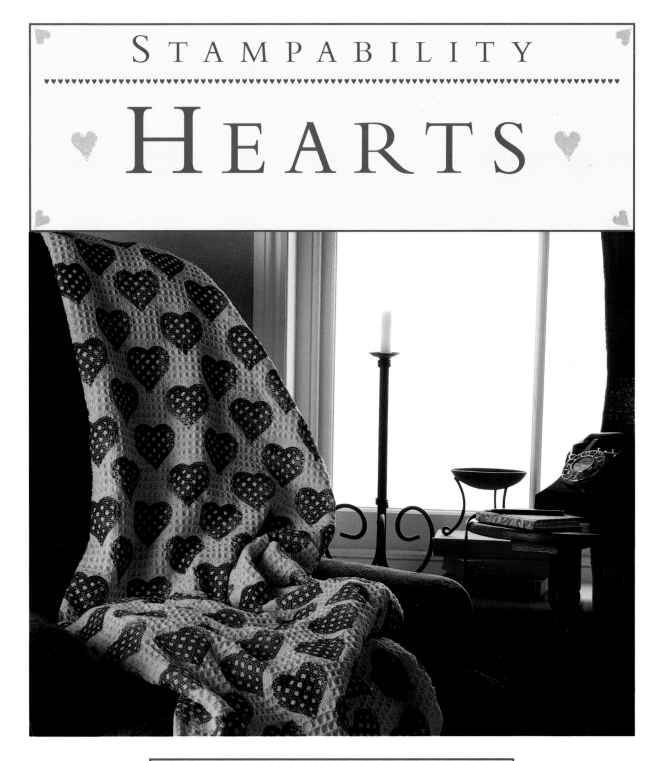

STEWART & SALLY WALTON

PHOTOGRAPHY BY GRAHAM RAE

LORENZ BOOKS

NEW YORK · LONDON · SYDNEY · BATH

CONTENTS

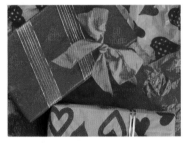

INTRODUCTION

EVERY NOW AND THEN there is a breakthrough in interior decorating – something suddenly captures the imagination. Stamping is definitely one such breakthrough and it is all the more popular as it needs neither special knowledge nor lots of money.

All you need is a stamp and some color and you can make a start. The idea comes from the office rubber stamp and it uses the same principle.

You can use stamps with a stamp pad, but a small foam roller gives a better effect. The stamp can be coated with ordinary household paint – this makes stamping a fairly inexpensive option, and gives you a wide range of colors to choose from.

There are stamping projects in this book ranging from making a sheet of wrapping paper to creating a new look for your kitchen. Each one is illustrated with clear step-by-step photographs and instructions. You are bound to progress on to your own projects once you've tried these suggestions because stamping really is easy. The added bonus is that you need very little equipment and there's hardly any clearing up to do afterward – what could be better?

This book focuses on the heart theme. The heart is the prime symbol of love and is often found in folk art and crafts. Many traditional country-style patterns for embroidery, metalwork, wood carving and ceramics also feature the heart. This is because these items were used to make items for a woman's marriage dowry. The early American settlers were especially fond of using hearts in their patterns, and the recent revival of interest in them has brought the heart right back into mainstream decorating.

The choice of color for your hearts can create many different styles – red is romantic, black is dramatic and pastels soften the mood. The effects which can be created with these heart stamps are almost endless and, whichever you try, you're just bound to love the result!

BASIC APPLICATION TECHNIQUES

Stamping is a simple and direct way of making a print. The variations, such as they are, come from the way in which the stamp is inked and the type of surface to which it is applied. The stamps used in the projects were inked with a foam roller which is easy to do and gives reliable results, but each application technique has its own character. It is a good idea to experiment and find the method and effect that you most prefer.

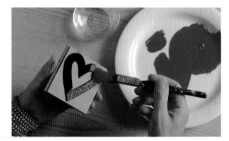

INKING WITH A BRUSH

The advantage of this technique is that you can see where the color has been applied. This method is quite time-consuming, so use it for smaller projects. It is ideal for inking an intricate stamp with more than one color.

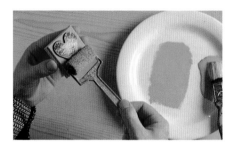

INKING WITH A FOAM ROLLER

This is the best method for stamping large areas, such as walls. The stamp is evenly inked and you can see where the color has been applied. Variations in the strength of printing can be achieved by re-inking the stamp after several printings.

INKING ON A STAMP PAD

This is the traditional way to ink rubber stamps, which are less porous than foam stamps. The method suits small projects, particularly those involving printing on paper. Stamp pads are more expensive to use than paint but are less messy, and will produce very crisp prints.

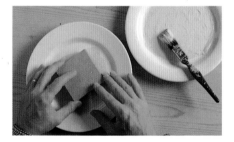

INKING BY DIPPING IN PAINT

Spread a thin layer of paint on to a flat plate and dip the stamp into it. This is the quickest way of stamping large decorating projects. As you cannot see how much paint the stamp is picking up, you will need to experiment.

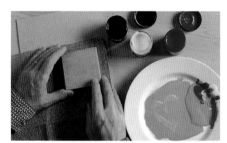

INKING WITH FABRIC PAINT

Spread a thin layer of fabric paint onto a flat plate and dip the stamp into it. Fabric paints are quite sticky and any excess paint is likely to be taken up in the fabric rather than to spread around the edges. Fabric paint can also be applied by brush or foam roller, and is available with built-in applicators.

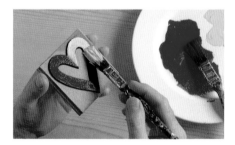

INKING WITH SEVERAL COLORS

A brush is the preferred option when using more than one color on a stamp. It allows greater accuracy than a foam roller because you can see exactly where you are putting the color. Two-color stamping is very effective for giving a shadow effect or a decorative pattern.

SURFACE APPLICATIONS

The surface onto which you stamp your design will greatly influence the finished effect.
Below are just some of the effects that can be achieved.

STAMPING ON ROUGH PLASTER

You can roughen your walls before stamping by mixing joint compound to a fairly loose consistency and spreading it randomly on the wall. When dry, roughen with coarse sandpaper, using random strokes.

STAMPING ON SMOOTH PLASTER OR WALLPAPER LINER

Ink the stamp with a small foam roller for the crispest print. You can create perfect repeats by re-inking with every print, whereas making several prints between inkings varies the strength of the prints and is more in keeping with hand-printing.

STAMPING ON WOOD

Rub down the surface of any wood to give the paint a better "tooth" to adhere to. Some woods are very porous and absorb paint, but you can intensify the color by over-printing later. Wood looks best lightly stamped so that the grain shows through. Seal your design with clear matte varnish.

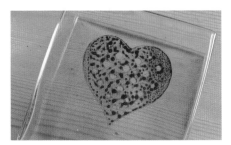

STAMPING ON GLASS

Wash glass in hot water and detergent to remove any dirt or grease and dry thoroughly. It is best to stamp on glass for non-food uses, such as vases or sun-catchers. Ink the stamp with a foam roller and practice on a spare sheet of glass. As glass has a slippery, non-porous surface, you need to apply the stamp with a direct on/off movement. Each print will have a slightly different character, and the glass's transparency allows the pattern to be viewed from all sides.

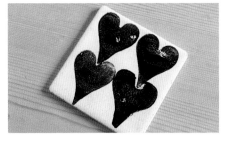

STAMPING ON TILES

Wash and dry glazed tiles thoroughly before stamping. If the tiles are already on the wall, avoid stamping in areas that require a lot of cleaning. The paint will only withstand a gentle wipe with a damp cloth. Loose tiles can be baked to add strength and permanence to the paint. Read the paint manufacturer's instructions (and disclaimers!) before you do this. Ink the stamp with a small foam roller and apply with a direct on/off movement.

STAMPING ON FABRIC

As a rule, natural fabrics are the most absorbent, but to judge the stamped effect, experiment on a small sample. Fabric paints come in a range of colors, but to obtain the subtler shades you may need to combine the primaries and black and white. Always place a sheet of cardboard behind the fabric to protect your work surface. Apply the fabric paint with a foam roller, brush or by dipping. You will need more paint than for a wall, as fabric absorbs the paint more efficiently.

PAINT EFFECTS

Once you have mastered the basics of stamp decorating, there are other techniques that you can use to enrich the patterns and add variety. Stamped patterns can be glazed over, rubbed down or over-printed to inject subtle or dramatic character changes.

STAMPING LATEX PAINT ON PLASTER, DISTRESSED WITH TINTED VARNISH

The stamped pattern will already have picked up the irregularities of the wall surface and, if you re-ink after several prints, some prints will look more faded than others. To give the appearance of old hand-blocked wallpaper, paint over the whole surface with a ready-mixed antiquing varnish. You can also add color to a varnish, but never mix a water-based product with an oil-based one.

STAMPING LATEX PAINT ON PLASTER, COLORED WITH TINTED VARNISH

It is possible to buy ready-mixed color-tinted varnish or you can add color to a clear varnish base. A blue tint will change a red into purple, a red will change yellow into orange, and so on. The color changes are gentle because the background changes at the same time.

STAMPING WITH WALLPAPER PASTE, WHITE GLUE AND WATERCOLOR PAINT

Mix three parts pre-mixed wallpaper paste with one part white glue and add watercolors. These come ready-mixed in bottles with built-in droppers. The colors are intense so you may only need a few drops. The combination gives a sticky substance which the stamp picks up well and which clings to the wall without drips. The white glue dries clear to give a bright, glazed finish.

STAMPING WITH A MIXTURE OF WALLPAPER PASTE AND LATEX PAINT

Mix up some wallpaper paste and add one part to two parts latex paint. This mixture makes a thicker print that is less opaque than the usual latex version. It also has a glazed surface that picks up the light.

STAMPING LATEX PAINT ON PLASTER, WITH A SHADOW EFFECT

Applying even pressure gives a flat, regular print. By pressing down more firmly on one side of the stamp you can create a shadow effect on one edge. This is most effective if you repeat the procedure, placing the emphasis on the same side each time.

STAMPING A DROPPED SHADOW EFFECT

To make a pattern appear three-dimensional, stamp each pattern twice. Make the first print in a dark color that shows up well against a mid-tone background. For the second print, move the stamp slightly to one side and use a lighter color.

DESIGNING WITH STAMPS

To design the pattern of stamps, you need to find a compromise between printing totally at random and measuring precisely to achieve a machine-printed regularity. To do this, you can use the stamp block itself to give you a means of measuring your pattern, or try strips of paper, squares of cardboard and lengths of string. Try using a stamp pad on scrap paper to plan your design but always wash and dry the stamp before proceeding to the main event.

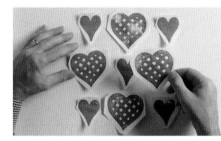

USING PAPER CUT-OUTS
The easiest way to plan your design is to stamp and cut out as many pattern elements as you need and use them to mark the position of your finished stamped prints.

CREATING A REPEAT PATTERN
Use a strip of paper as a measuring device for repeat patterns. Cut the strip the length of one row of the pattern. Use the stamp block to mark where each print will go, with equal spaces in between. You could also make a vertical strip. Position the horizontal strip against this as you print.

USING A PAPER SPACING DEVICE
This method is very simple. Decide on the distance between prints and cut a strip of paper to that size. Each time you stamp, place the strip against the edge of the previous print and line up the edge of the block with the other side of the strip. Use a longer strip to measure the distance required.

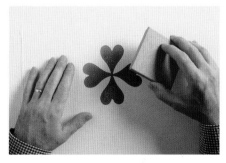

CREATING AN IRREGULAR PATTERN
If your design doesn't fit into a regular grid, plan the pattern first on paper. Cut out paper shapes to represent the spaces and use these to position the finished pattern. Alternatively, raise a motif above the previous one by stamping above a strip of cardboard positioned on the baseline.

DEVISING A LARGER MOTIF
Use the stamps in groups to make up a larger design. Try stamping four together in a block, or partially overlapping an edge so that only a section of the stamp is shown. Use the stamps upside down, back to back and rotated in different ways. Experiment on scrap paper first.

USING A PLUMBLINE
Attach a plumbline at ceiling height to hang down the wall. Hold a cardboard square behind the plumbline so that the string cuts through two opposite corners. Mark all four points, then move the cardboard square down. Continue in this way to make a grid for stamping a regular pattern.

TREASURE BOXES

Sets of lidded round boxes made from lightweight wood, cardboard or papier-mâché are imported from the Far East and are readily available in stores. The plain ones, sometimes called blanks, are not expensive and they make the ideal base for some imaginative stamping work.

The hearts in this project have been grouped to form a larger motif, with some of them only partially stamped, so they don't look like hearts. As you can see, experimentation produces all sorts of variations on the heart theme.

YOU WILL NEED
set of plain, round boxes with lids
latex or acrylic paint in light gray, yellow
and black
paintbrush
plate
foam roller
large and small heart stamps

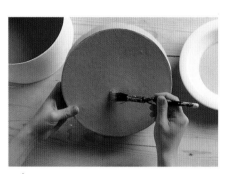

1 Paint the lid of the box light gray with latex or acrylic paint. Let dry. If extra coverage is necessary, apply more than one coat, letting paint dry between coats.

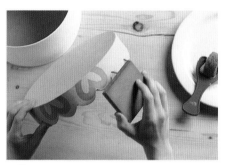

2 Spread some yellow paint onto the plate and run the roller through it until it is evenly coated. Then ink the large stamp. Print the top half of the heart around the side of the lid. Do not print the hearts too closely together – use the stamp to estimate the spacing before you begin.

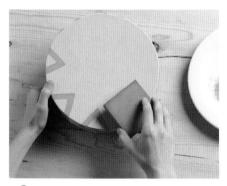

3 Align the stamp with the pattern printed on the side of the lid, then print the pointed part of each heart around the top of the lid. This gives the impression that the heart has been folded over.

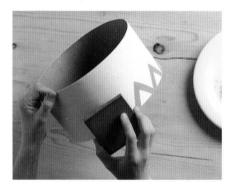

4 Use the same pointed part of the heart to print a zigzag border around the bottom edge of the box.

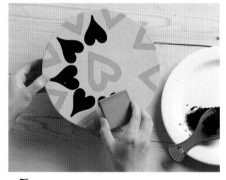

5 Still using the yellow paint, stamp one complete large heart in the center of the lid. Ink the small stamp with black paint and stamp a circle of hearts with their points radiating outward between the yellow "V" shapes.

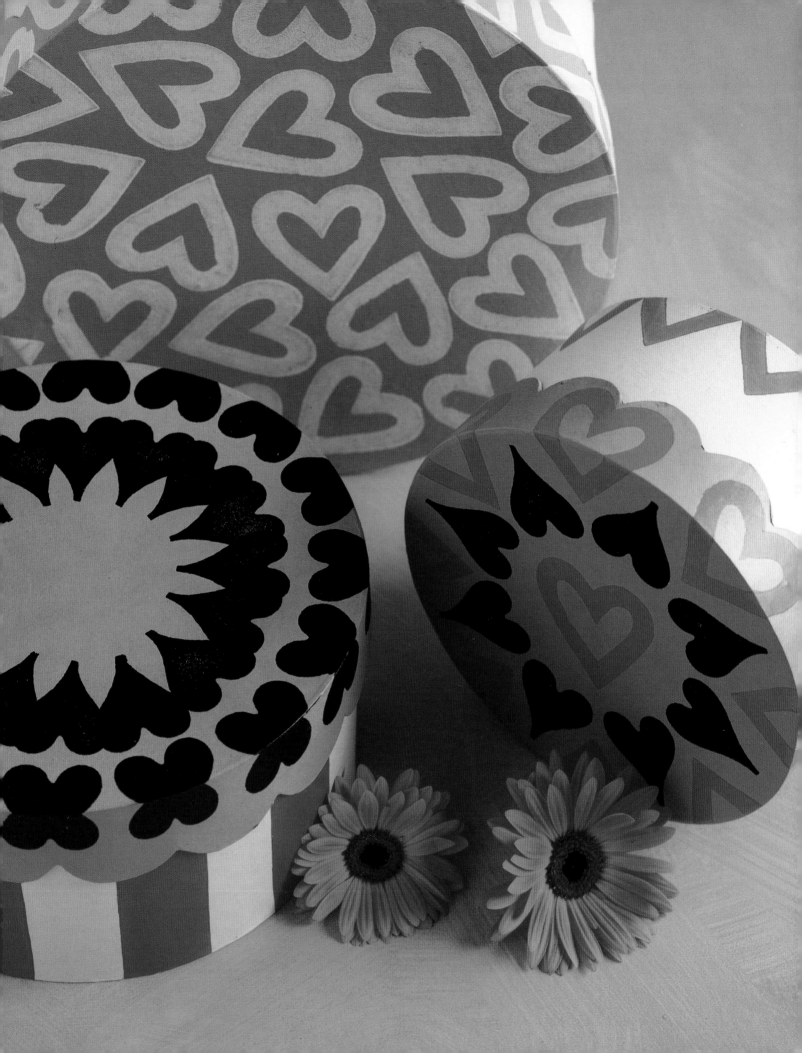

Nursery Walls

Children are often bombarded with a riot of primary colors or surrounded in pretty pastels, so this dark color scheme provides an unusual and refreshing change. It gives the room a wonderful period feel and the deep blue-green shade is known for its calming effect.

You can offset the dark color by painting a light color above the chair rail and laying a lighter, natural floor covering like sisal or cork tiles. The effect is rich and intense.

This idea can be adapted to any color scheme you like and you can reverse the effect by using a light background with darker stamps. Experiment with colors and shades and you'll often find that unusual combinations create the most stunning impact.

YOU WILL NEED
latex paint in deep blue-green,
sap-green and red
paintbrush
plate
foam roller
large heart stamp
water-based matte varnish and paintbrush
(optional)

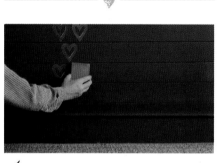

1 Paint the wall below the chair rail in deep blue-green. Let dry. Spread a small amount of sap-green paint onto the plate and run the roller through it until it is evenly coated. Ink the stamp and begin printing the pattern in groups. Re-ink the stamp only when the print is very light.

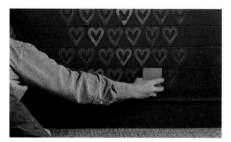

2 Gradually build up the pattern all over the wall. The first prints after inking will be solid and bright; the last ones will fade into the background. This is a feature of the design, so make the most of the natural irregularities.

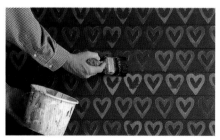

3 This is an optional step. If you find that the contrasts are too strong, mix some varnish with the blue-green paint (one part paint to five parts varnish) and brush it all over the pattern. Let dry.

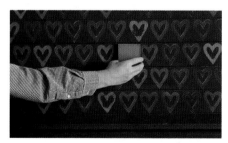

4 Ink the stamp with red paint and over-print every third heart in the top row. Then over-print every third heart in the next row, this time starting one in from the edge. Repeat these two rows to over-print the whole pattern. Re-ink when the color has faded.

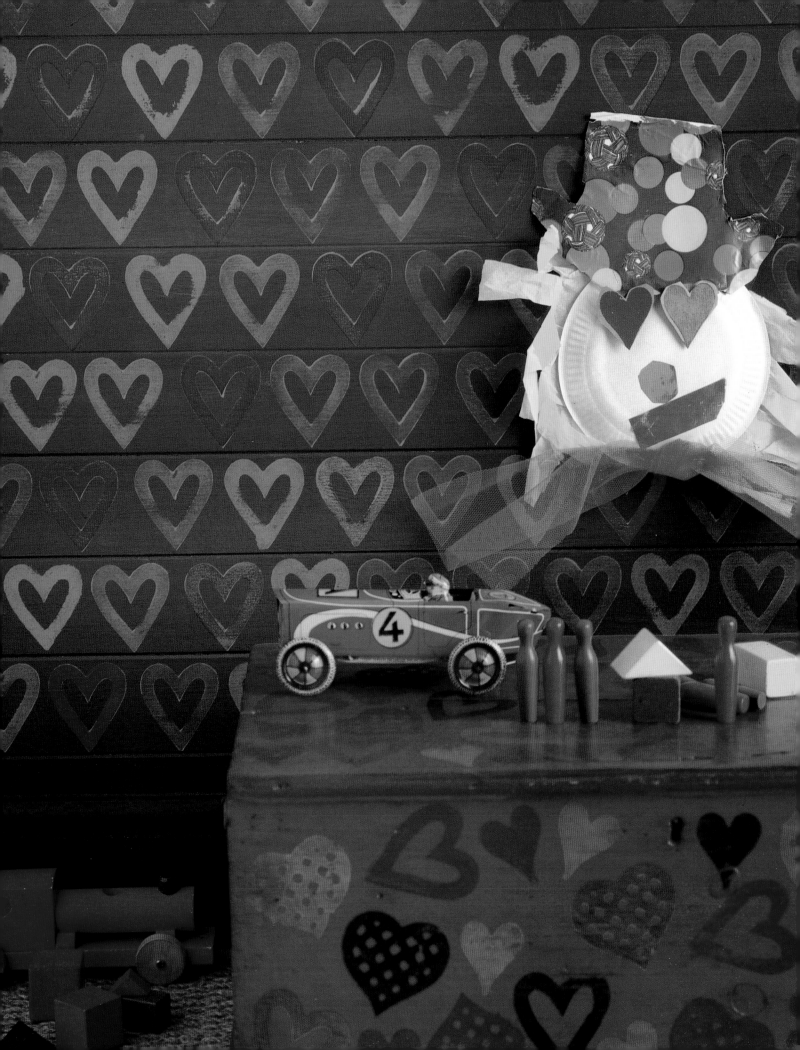

Toy Box

This project gives instant appeal to the most ordinary of wooden boxes. It works just as well on old as new woods but, if you are using an old box, give it a good rubdown with medium- and fine-grade sandpaper before you begin. This will remove any sharp edges or splinters. The lid of the box is given a rust-red background before being stamped with three heart shapes in four colors. The stamps are rotated so that they appear at different angles and the pattern turns out quite randomly. It is best to follow the spirit of the idea rather than adhering rigidly to the instructions. That way, you will end up with a truly individual design.

YOU WILL NEED
hinged wooden chest/box with a lid
(suitable for storing toys)
rust-red latex paint
latex or acrylic paint in maroon, sap-green,
bright green and dark blue
paintbrush
plate
foam roller
small, large and trellis heart stamps
fine-grade sandpaper
matte varnish and paintbrush

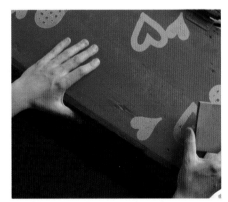

1 Paint the box with rust-red paint, applying two coats to give a good matte background. Let the paint dry between coats.

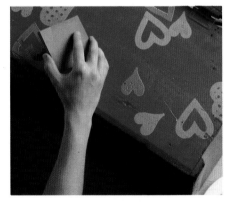

2 Spread some maroon paint onto the plate and run the roller through it until it is evenly coated. Use the roller to apply a border around the edge of the lid. Let dry.

3 Spread some sap-green paint onto the plate and coat the roller. Ink the small stamp and print a few hearts randomly over the lid of the box.

4 Ink the large and the trellis stamps with the sap-green paint. Print some hearts close together and others on their own to create a random pattern. Cover the whole lid in this way.

5 Clean all three stamps and ink with the bright green paint. Build up the pattern by adding this color in the gaps, leaving enough space for the last two colors.

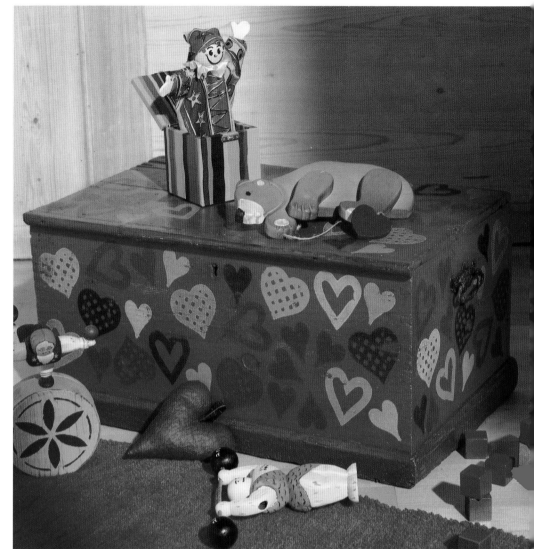

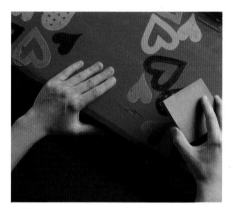

6 Using the dark blue paint, continue stamping the three hearts over the lid.

7 Finally, fill in the remaining background space with the maroon paint and the three heart stamps. No large spaces should remain. Let dry completely.

8 Use fine-grade sandpaper to rub down the lid where you think natural wear and tear would be the most likely to occur.

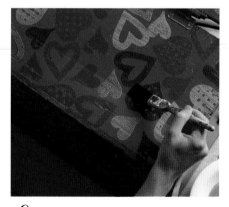

9 You can preserve the comfortable "weathered" look of the toy box by applying two coats of matte varnish.

GLASS VASE

Take a plain vase and stamp it with rows of primary-colored hearts to create a bright and cheerful display piece. Instead of being purely functional, the vase becomes artistic and decorative – this is one to put on the mantelpiece with or without cut flowers.

There are now some paints available called acrylic enamels. These are suitable for use on glass and ceramics and they give a hard-wearing finish that stands up to non-abrasive washing. The selection of colors is great, so take a look at them and try some glass stamping!

YOU WILL NEED
glass vase
kitchen cloth
acrylic enamel paints in yellow, blue
and red
plate
foam roller
small heart stamp

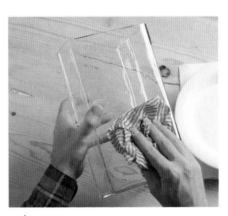

1 Wash the vase to remove any grease from the surface and dry it thoroughly. This will give you a better surface for stamping and will ensure a more successful print.

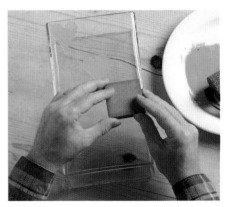

2 Spread a small amount of yellow paint onto the plate and run the roller through it until it is evenly coated. Ink the stamp and print a diagonal row of hearts, starting at the top lefthand corner. Stamp onto the glass, lifting the stamp directly so that the print is crisp and does not smudge.

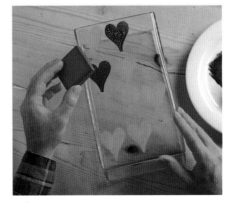

3 Clean the stamp and ink it with blue paint. Add blue hearts in between the yellow ones as shown.

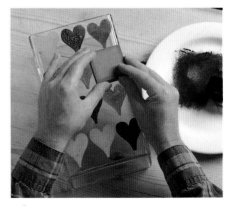

4 Clean the stamp and ink it with red paint. Then complete the design by adding the red hearts.

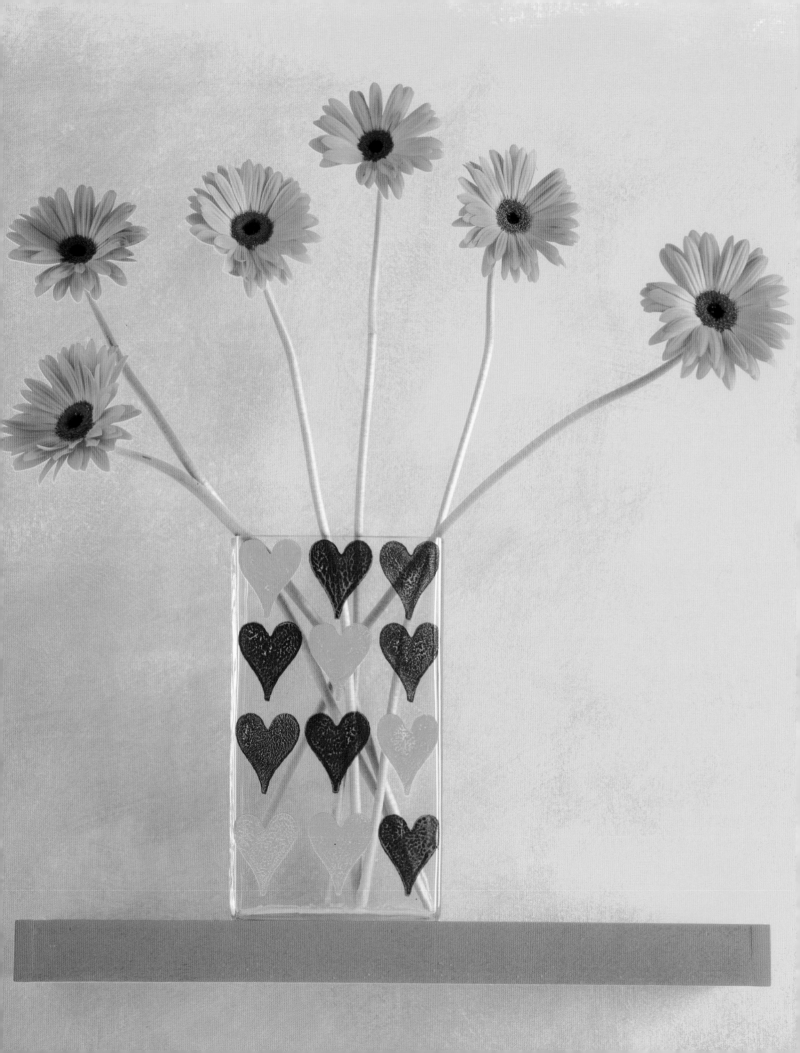

WRAPPING PAPER

Here is a way to print your own wrapping paper that will look better than anything at the store. The design will be unique and it hardly costs anything at all, unlike the hand-printed top-of-the-line designs available commercially. People have always enjoyed the satisfying activity of making repeat patterns, and nowadays we only really get a chance to do so at preschool. But now you can grab some sheets of plain paper or colorful tissue paper, clear the kitchen table and start stamping lots of different patterns.

YOU WILL NEED
acrylic paint in red and gold
plate
foam roller
trellis, small and large heart stamps
selection of plain, colored paper (such as tissue paper and brown parcel wrap)

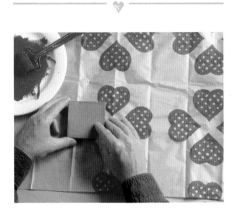

1 Spread a small amount of red paint onto the plate and run the roller through it until it is evenly coated. Ink the trellis stamp and print blocks of four hearts with the points facing inward onto the paper.

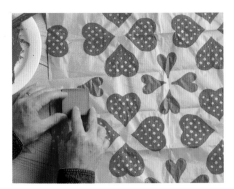

2 Ink the small stamp with red paint and print the same formation of hearts in the spaces between the trellis prints.

3 To make a second design, ink the large stamp with red paint and print a random, widely spaced pattern onto a piece of paper. Turn the stamp in your hand each time, so that the direction of the print changes.

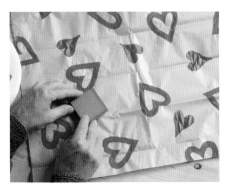

4 Ink the small stamp with red paint and stamp hearts between the larger hearts in the same way.

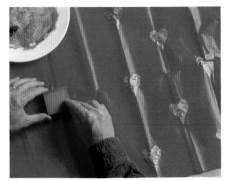

5 For a third option, spread some gold paint onto the plate and ink the small stamp with it. Stamp a formal pattern of widely spaced rows of hearts. Judge the spacing visually, as slight irregularities will not show once the paper is wrapped around a gift.

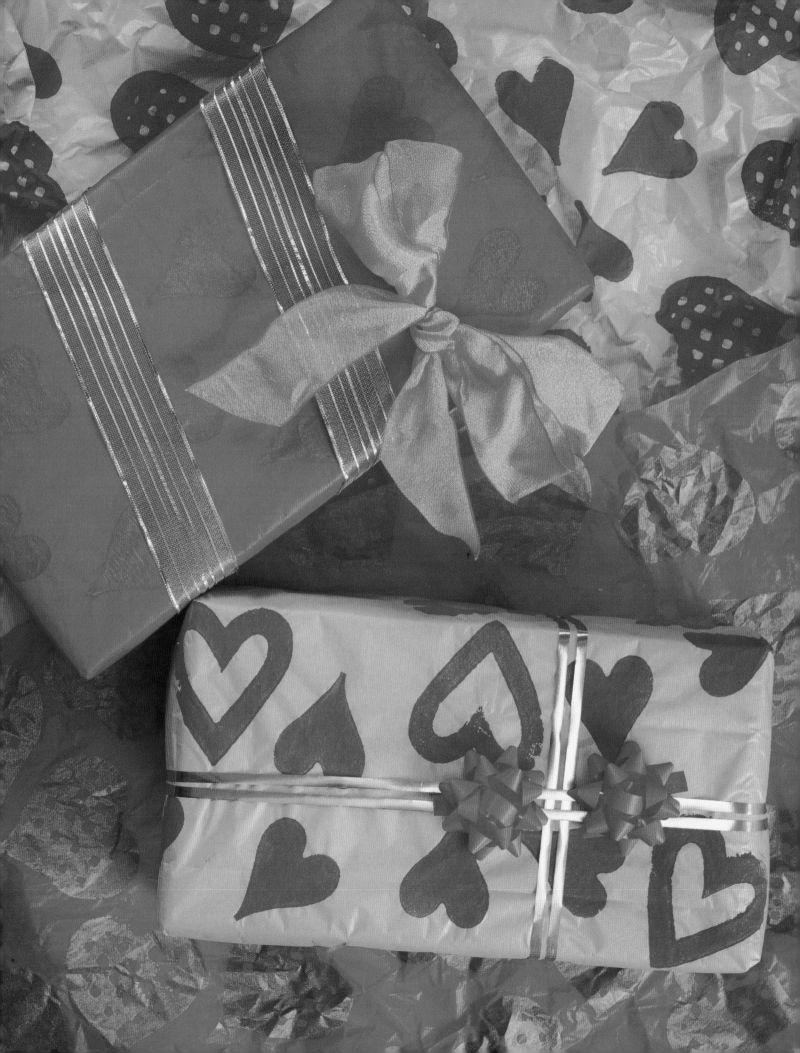

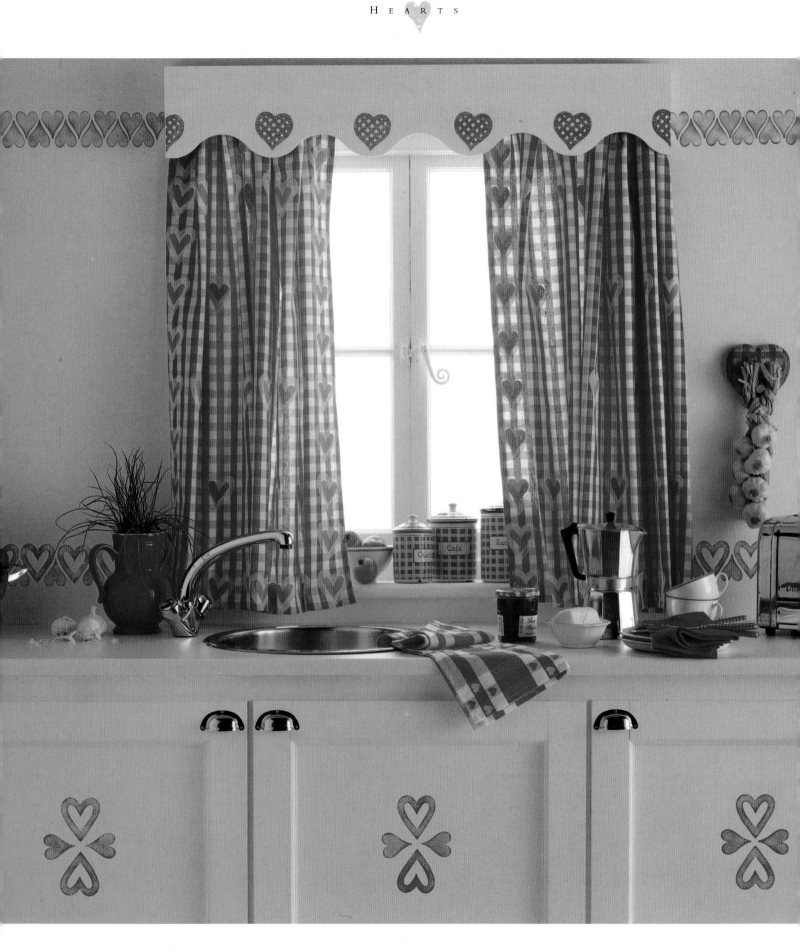

SCANDINAVIAN KITCHEN

Replacing a kitchen is one of the major financial outlays facing a homeowner,
and also a major disruption. It often involves waiting a long time for your dream kitchen
while you put up with an outdated and intensely disliked one.
This project will revitalize and update your existing kitchen so that you may well stop pining for that
renovation altogether. The most time-consuming part of the project is painting the cabinets and
walls white, but once you've done that, you can stamp on the heart pattern that really makes the
change. Don't worry if you've got formica cabinets, as they can be cleaned to remove any grease and
then painted with an oil-based matte paint such as eggshell or satinwood. If your units are white, but
very clinical, you can brighten them up by adding red wooden handles to match the hearts.
Start this project on a Saturday morning and you could have a new-look kitchen
by the end of the weekend.

YOU WILL NEED
thick cardboard
scissors
red latex paint
plate
foam roller
small and large heart stamps
paper towels
ruler
pencil
clear matte varnish and brush (optional)
red and white gingham curtains
*backing paper (such as thin cardboard or
newspaper)*
fabric paint in pink and white
iron

1 Cut a square of thick cardboard, approximately 12x12in. To stamp the top frieze, hold the cardboard square against the wall with the top edge resting against the ceiling. Assuming that the ceiling is at a right angle to the wall, this will give you a straight line to follow. Otherwise, you will need to make adjustments visually.

Spread some red paint onto the plate and run the roller through it until it is evenly coated. Ink the small stamp and begin printing in the lefthand corner. Butt the edge of the stamp block up against the cardboard square and print a close row of hearts.

2 Print the first heart in the second row with the point facing up. Align the cardboard square with the bottom of the print and hold it in place to keep a straight line along the row.

▶

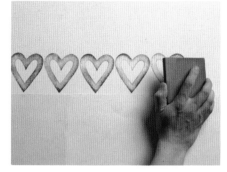

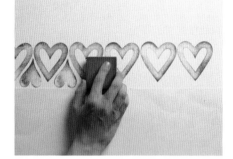

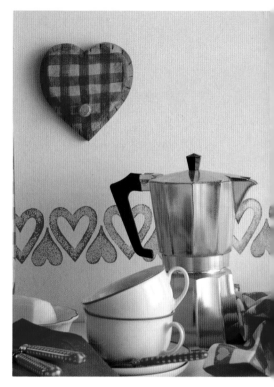

3 To print the frieze above the work surface, first cut out a piece of thick cardboard the width of the desired gap between the work surface and the border. Place this against the wall, resting on the work surface, and rest the base of the stamp block on it.

Ink the large stamp with red paint and then blot it before stamping so that the print is very light and airy.

4 Ink the small stamp and print a row of upside-down hearts between the large hearts.

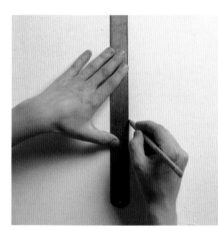

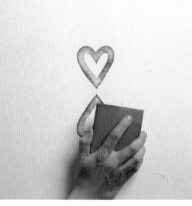

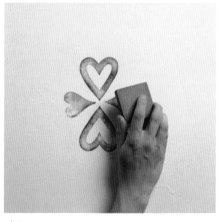

5 To print the cabinets, use a ruler and pencil to mark the center point of each cabinet door.

6 Ink the large stamp and print one heart above the center point and one below so that the points face inward.

7 Ink the small stamp and print a heart on either side of the center point with the points facing inward. The cabinet doors can be protected by applying a coat of varnish.

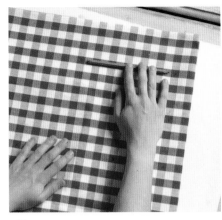

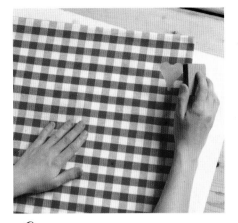

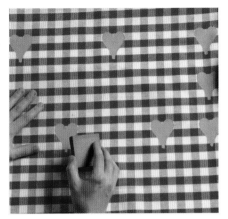

8 To print the curtains, protect your work surface with a large sheet of paper and spread the fabric over this. Put the curtains on some backing paper on a work surface.

9 Spread some pink fabric paint onto the plate and run the roller through it until it is evenly coated. Ink the small stamp and print pink hearts down the side edges with two red squares between each one.

10 Stamp pink hearts across the fabric, counting six red squares between the points on the first row. Then begin the second row six squares down and three across. Repeat these two rows to cover both the curtains.

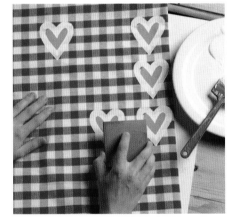

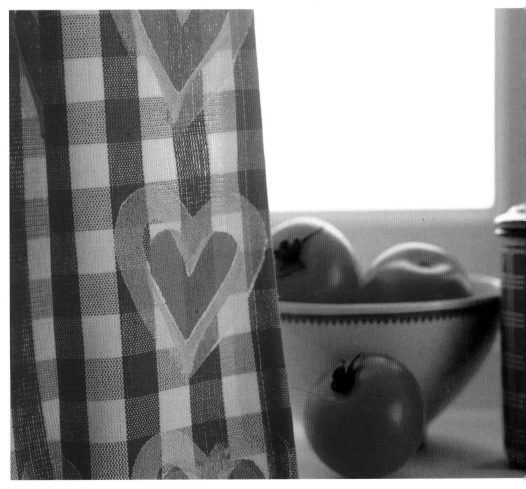

11 Ink the large stamp with white fabric paint, then over-print all the pink hearts. Fix the fabric paint with a hot iron following the manufacturer's instructions.

COUNTRY-STYLE THROW

It's hard to imagine a home without a throw. Throws not only hide a multitude of sins
like stains and worn patches, but they can instantly change the mood of a room with their colors
and patterns. A casually draped throw gives off a wonderful sense of relaxation and comfort.
The textured throw used in this project illustrates how well stamp prints can work on all sorts of
surfaces, and most fabrics would be suitable. Fabric paints are easy to use – in fact most fabrics absorb
the color instantly, which means there is less chance of smudging than there would be on a smooth,
non-porous surface such as wood or shiny paper.
Always use a piece of backing paper when printing on fabric.

YOU WILL NEED
plain-colored throw (or suitable length of
fabric with a hemmed edge)
iron
backing paper (such as thin cardboard or
newspaper)
fabric paint in red, blue and purple
plate
paintbrush (for mixing)
foam roller
trellis heart stamp
scrap paper

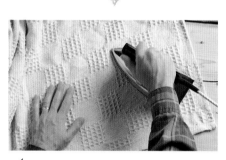

1 Press the throw or fabric with a
hot iron so that it lies flat. Place it on
some backing paper on a work surface.

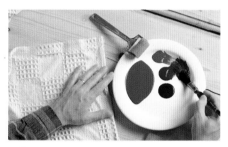

2 Put the three fabric paints onto
the plate and mix them together to
create a violet-blue color. Run the
roller through the paint until it is
evenly coated, then ink the stamp.

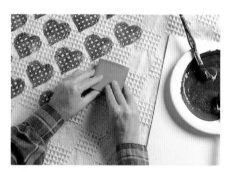

3 Starting in the top lefthand
corner, about 1¹/₂in in from the edge,
stamp a row of hearts – if you don't
have a checkerboard pattern to follow,
space them about 2in apart. Stamp the
next row between the hearts in the
first row. Overlap the rows by ³/₄in.

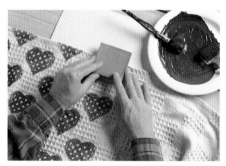

4 Take the design right up to the
edge, printing part of the heart where
it overlaps the edge. Have a sheet of
scrap paper in place to take up the
unwanted paint. Let the design dry
before fixing it with a hot iron accord-
ing to the manufacturer's instructions.

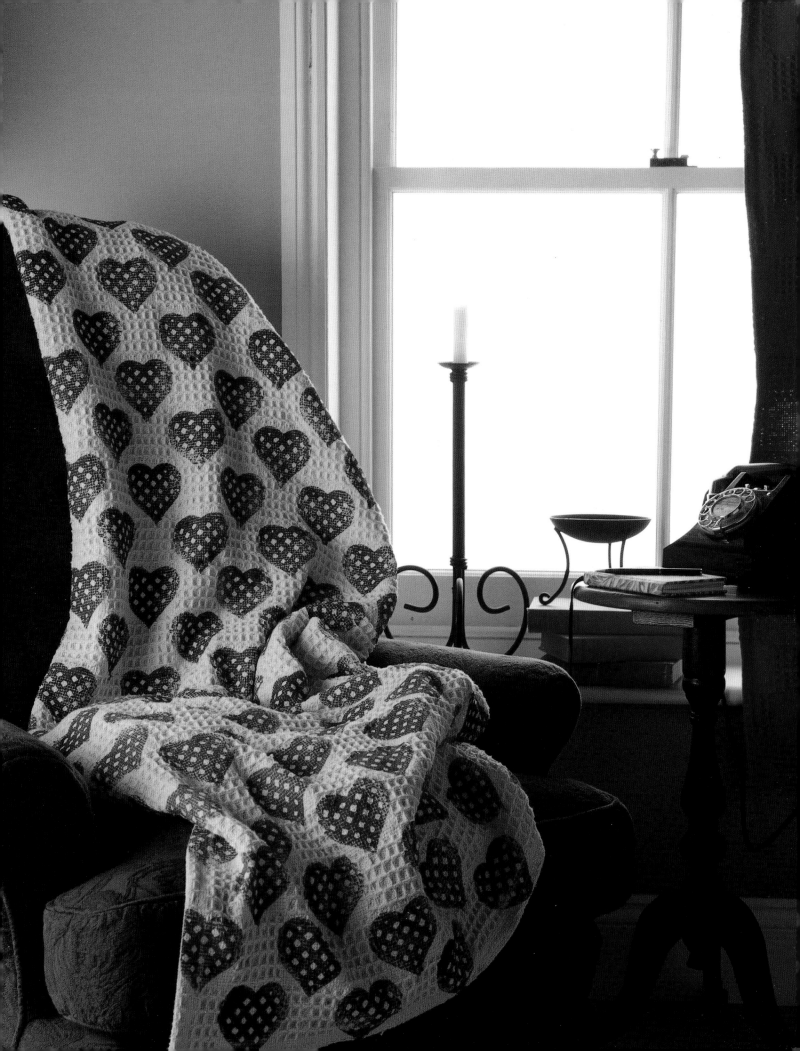

DECORATED TILES

These days you can buy wonderful decorated tiles in all shapes and sizes, but there is a drawback – they cost a fortune! So, why not use stamps and paint to make your own set of exclusive decorated tiles? These are not only much cheaper but also more individual.

Acrylic enamel paint is new on the market and although it resembles ordinary enamel, it is in fact water-based and does not include harmful solvents. If you are decorating loose tiles, bake them in a kitchen oven to "fire" the color and give added strength and permanence. You could use these fired tiles round basins and work surfaces or in showers as the designs will be waterproof and resilient to non-abrasive cleaning. Follow the paint manufacturer's instructions, but the paints are often a lot tougher than they dare to claim.

If you are stamping onto a tiled wall, it is best to position the design where it will not need too much cleaning – the paint will certainly withstand an occasional soaking and can be wiped with a damp cloth. Any more vigorous cleaning will remove the paint.

YOU WILL NEED
tiles
detergent and kitchen cloth
acrylic enamel paints in
blue and green
plate
foam roller
small, large and trellis heart stamps

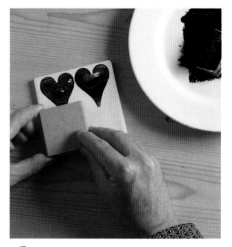

1 Wash the tiles with detergent and hot water, then dry them thoroughly before you apply any paint. They must be clean and grease-free.

2 Spread some blue paint onto the plate and run the roller through it until it is evenly coated. Ink the small stamp and print two hearts at the top of the tile, with equal spacing on either side.

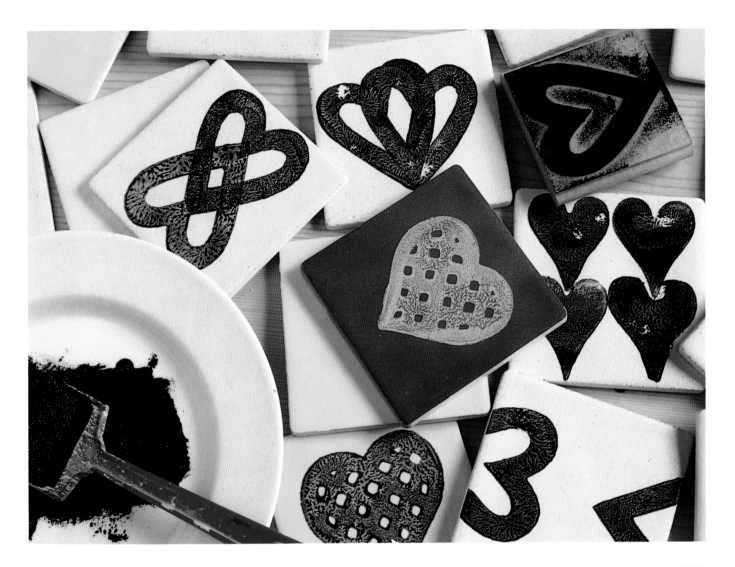

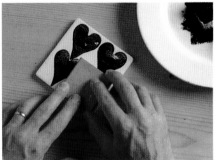

3 Align the next two stamps directly below the first. Be careful not to smudge the first two when stamping the second row. Acrylic paint dries fast, so you only need to wait a few minutes to avoid smudges.

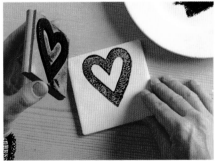

4 Ink the large heart and make a single print on an off-white tile. Press the stamp down, then lift off immediately to get an interesting surface texture.

5 Ink the large heart and print, overlapping the edges, so that the point is at the top edge of the tile and the curved part is at the bottom. This design is shown in the bottom right of the picture above. ▶

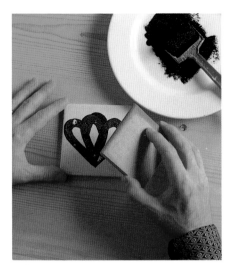

6 Ink the large heart and make the first print with the heart angled to the left. Let dry, then print another heart angled to the right.

7 Spread some green paint onto the plate and run the roller through it until it is evenly coated. Ink the trellis stamp and print a single heart on a plain tile.

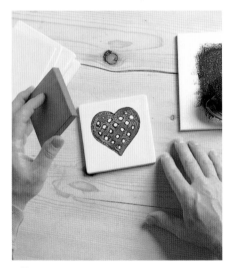

8 Continue printing a single trellis heart in the center of each tile. The texture will be different on every print, making the tiles look far more interesting and handpainted. They can be used alternately with solid tiles in a kitchen or bathroom.

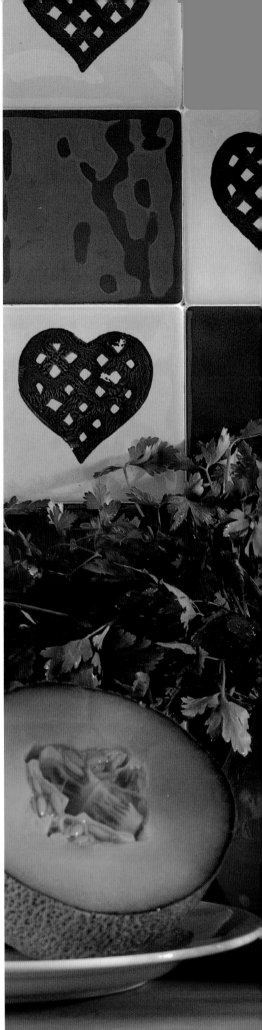

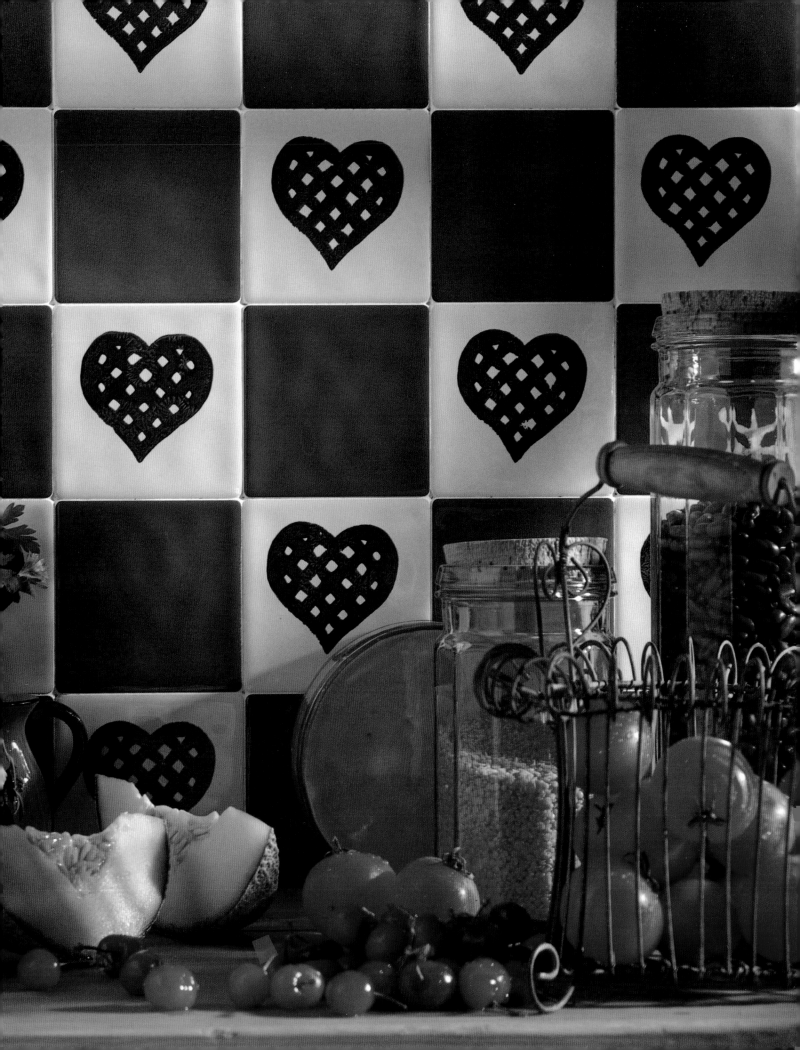

WHITE LACE PILLOWCASES

Attractive, lace-edged pillowcases are now mass-produced and imported at very reasonable prices. You can buy many different patterns ranging from hand-crocheted cotton to Battenburg-style cutwork. Choose a selection of different patterns, then stamp on top of them with delicate pink hearts to make a romantic display for the bedroom.

Fabric paints work very well on cotton, but it is advisable to wash and iron the cases before you stamp them. This removes the glaze that might block the paint's absorption.

YOU WILL NEED
lace-edged, white pillowcases
iron
ruler
pencil
backing paper (such as thin cardboard or newspaper)
pale pink fabric paint
plate
foam roller
small heart stamp

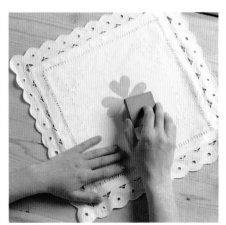

1 Wash and iron the pillowcases to give a crisp, flat surface.

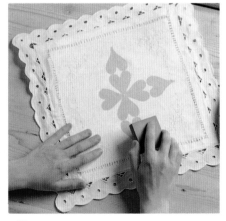

2 Using a ruler, measure between the corners to find the center of the pillowcase. Make a small pencil mark at this point.

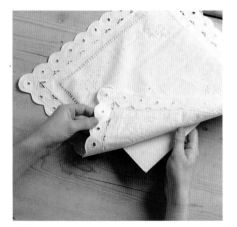

3 Place the backing paper inside the pillowcase between the two layers so that the color does not pass through to the other side.

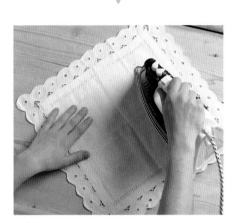

4 Spread some pale pink paint onto the plate and run the roller through it until it is evenly coated, then ink the stamp. Print a group of four hearts so that the points meet at the central pencil mark.

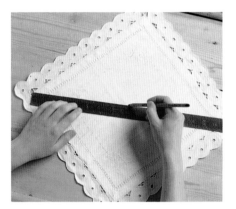

5 Stamp another four hearts in line with the first, but with the points facing outward. Let dry before fixing with a hot iron according to the manufacturer's instructions. Experiment with other designs.

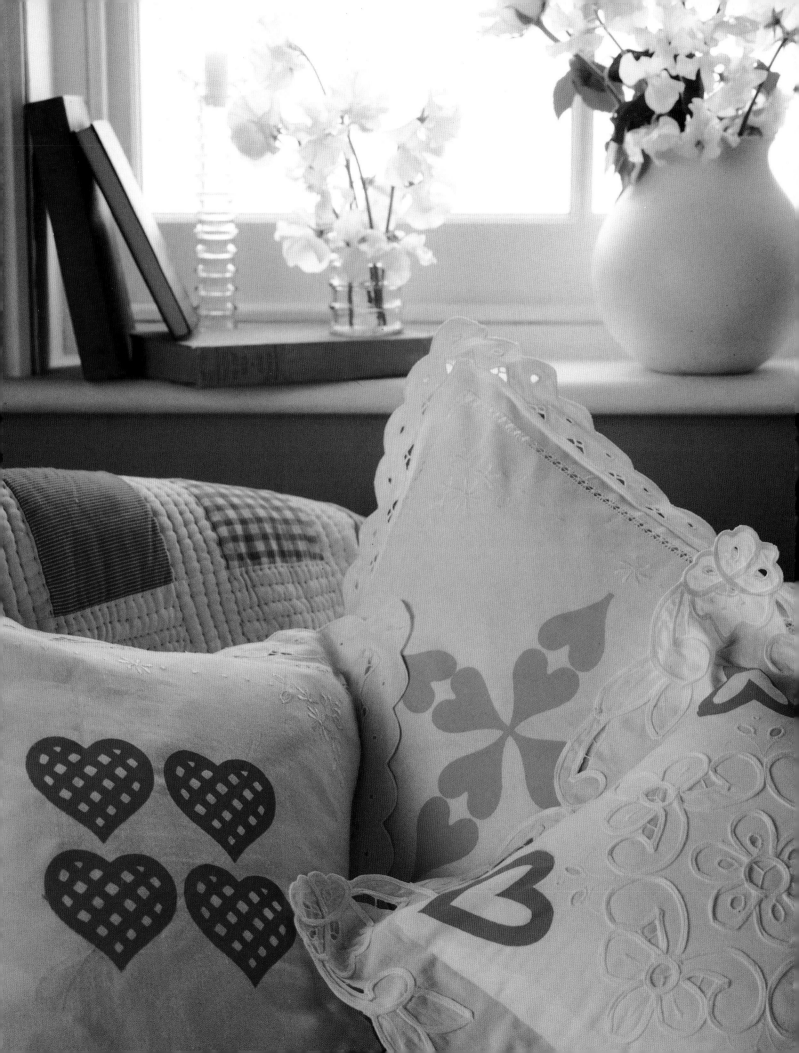

This edition published in 1996 by Lorenz Books
an imprint of Anness Publishing Limited
Administrative office:
27 West 20th Street
New York, NY 10011

Lorenz Books are available for bulk purchase, for sales promotion, and for premium use. For details write or call the manager of special sales, 27 West 20th Street, New York, NY10011; (212) 807 6739

ISBN 1 85967 240 X

Publisher: Joanna Lorenz
Senior Editor: Lindsay Porter
Assistant Editor: Sarah Ainley
Designer: Bobbie Colgate Stone
Photographer: Graham Rae
Stylist: Diana Civil

3 5 7 9 10 8 6 4 2

Printed and bound in Singapore